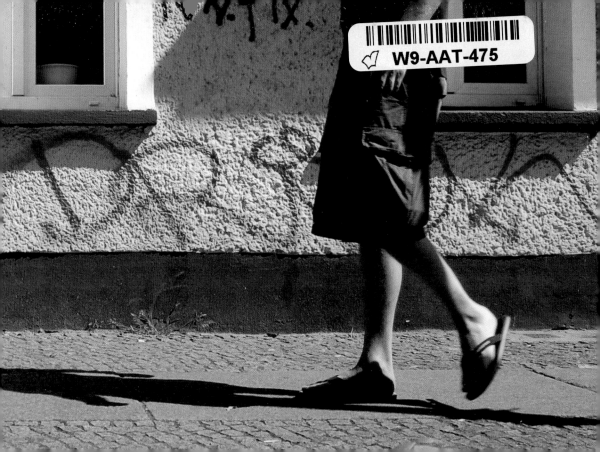

W9-AAT-475

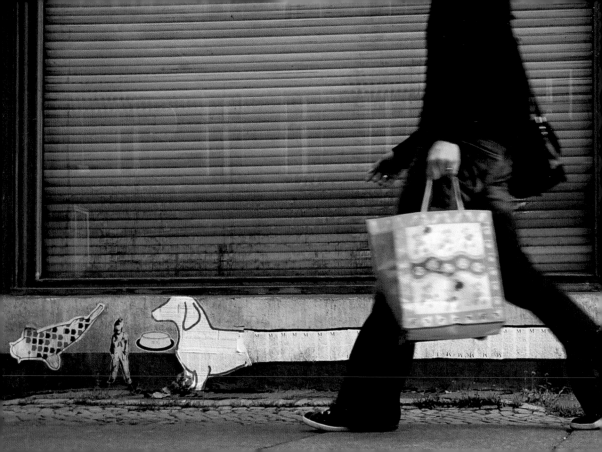

Sven Zimmermann

BERLIN STREET ART 2

Prestel Munich · Berlin · London · New York

Dieses Buch schließt nahtlos an den ersten Band an und verbindet damit sechs Jahre Berliner Street Art. Alte Bekannte der Szene sind weiterhin aktiv, viele neue sind dazu gekommen, und immer noch ist die Szene bunt und kreativ. Die Auswahl der Motive/Fotografien ist wie im ersten Teil rein subjektiv. Sie hat nicht den Anspruch, die Berliner Street-Art-Szene in ihrer Gänze darzustellen. Im Gegenteil, sie ist ein Einstieg in die Szene – wer mehr wissen will, kann selbst den Spuren folgen und sich auf vielfältigen Websites im Netz informieren. Eine Auswahl hierzu findet sich am Ende des Buches. Zudem gibt es in der Zwischenzeit auch eine Vielzahl an interessanten Büchern, die sich auf unterschiedlichste Art und Weise mit dem Thema Street Art beschäftigen.

Für viele ist Street Art zwar immer noch eine Erscheinungsform von Vandalismus und damit Sachbeschädigung, als subkulturelle und urbane Kunstform hat sie sich jedoch längst etabliert und damit nachhaltig das Stadtbild geprägt.

Dass sie mittlerweile fernab von der Straße auch in Galerien zu Hause ist, sich auf T-Shirts, in Büchern oder gar in Werbekampagnen wiederfindet, mag nicht jedem schmecken, aber letztendlich hat diese Entwicklung auch dazu beigetragen, dass Street Art von immer mehr Menschen wahrgenommen und oftmals auch toleriert wird. So hat Street Art nicht nur den öffentlichen Raum maßgeblich mit gestaltet, sondern sich auch in anderen Bereichen, wie Kunst, Mode oder Werbung weiter entwickelt. Street Art, als Teil unserer Lebenswelt, ist damit auch Inspiration. Und diese Kraft ist es, die Street Art zu etwas Besonderem macht.

Inspire Your City! Berlin 2008

Berlin Street Art 2 follows on seamlessly from the first volume, therewith connecting six years of Berlin street art. Old acquaintances are still active, many new faces have joined, and the scene is still as vibrant and creative as it ever was. As in *Berlin Street Art*, the selection of images was made on an entirely subjective basis. Rather than representing all of Berlin's street art , the aim of this selection is to provide a first introduction to the topic. Those who want to find out more may follow the trail across Berlin or browse through the great variety of websites flourishing on the WWW. A choice of web links is provided at the end of this book.

Whereas to many people street art is still a manifestation of vandalism and as such willful damage of property, it has established itself as a subculture and urban form of art, leaving a lasting impression on the cityscape.

Not everyone may appreciate the fact that this art form has, far beyond the street, found a home in galleries and is featured on T-shirts, in books, or even in advertising campaigns. Ultimately, however, this development has contributed to the fact that street art is being seen and tolerated by more and more people worldwide. Street art has not only shaped the public space, it is continuing to develop in other areas such as art and fashion. As a part of our lifestyle, street art is also a source of inspiration. It is this particular strength that makes street art so special.

Inspire Your City! Berlin 2008

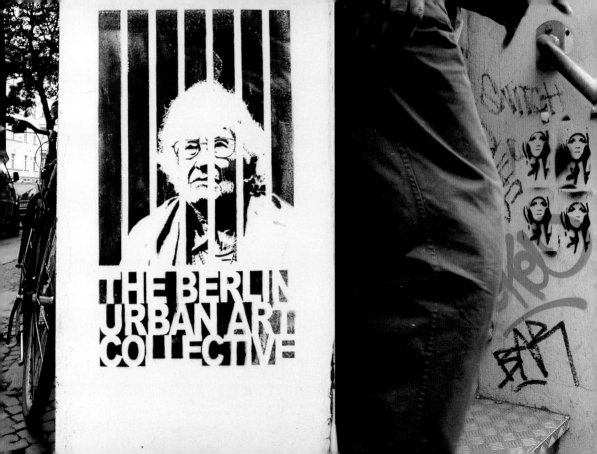

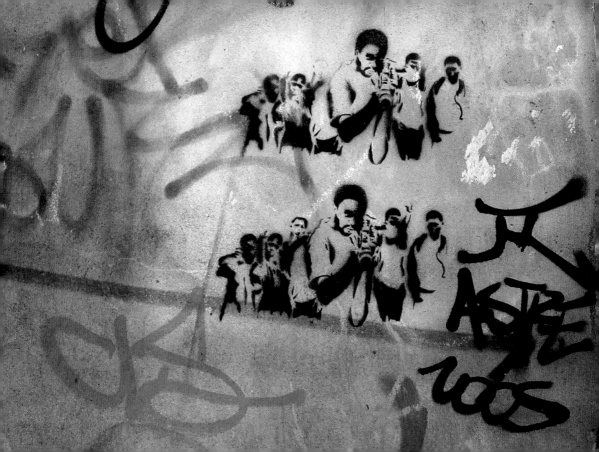

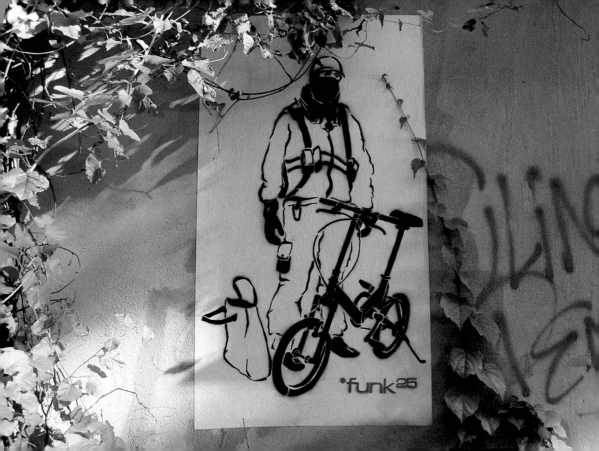

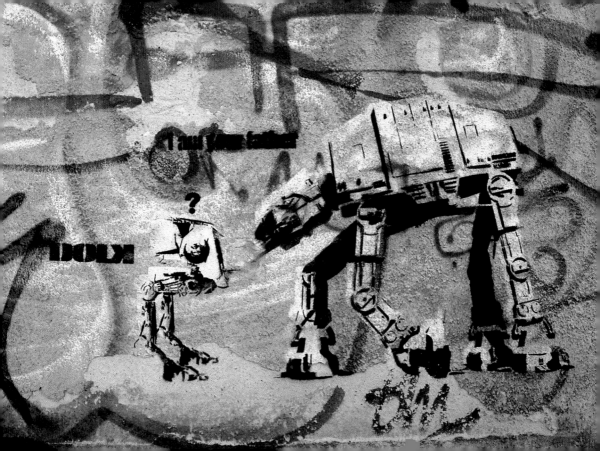

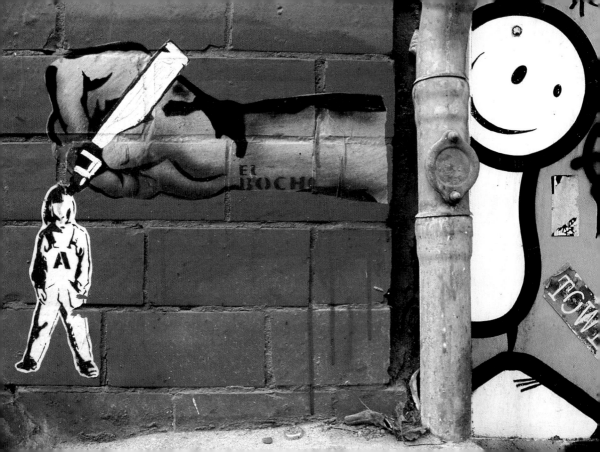

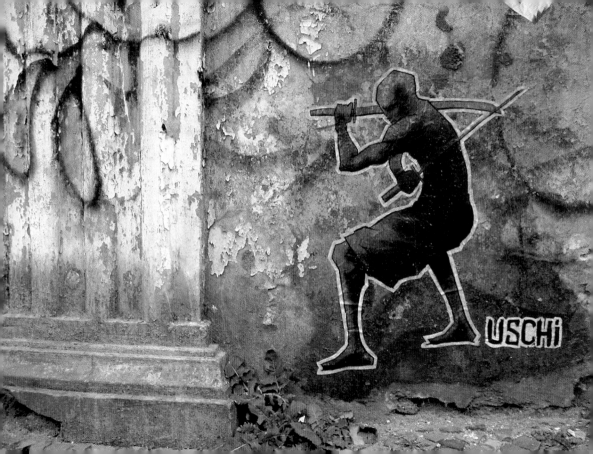

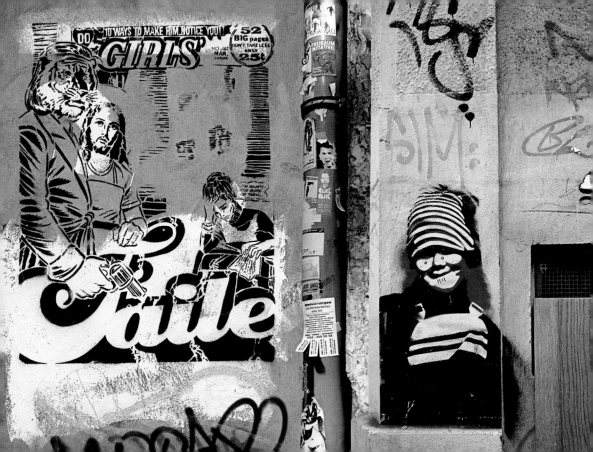

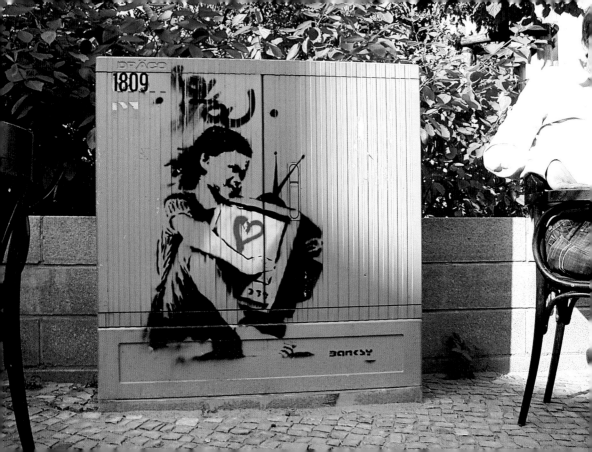

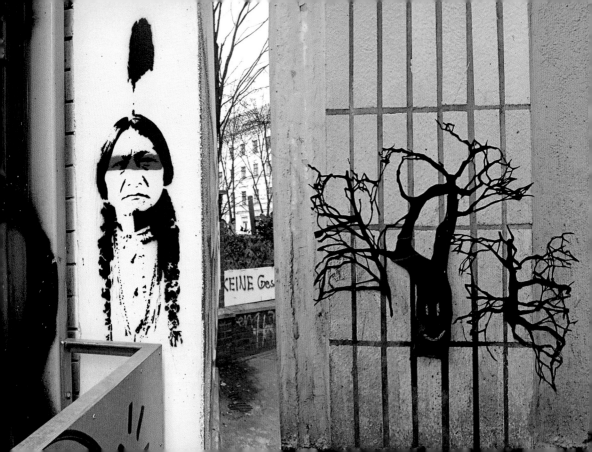

ART-WAR !

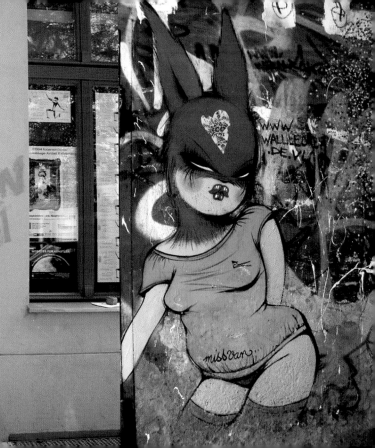

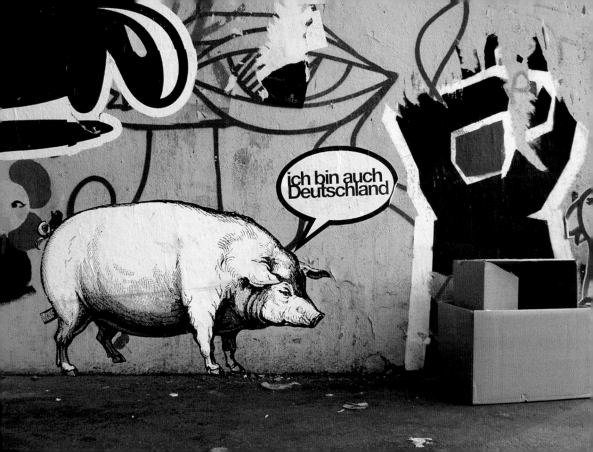

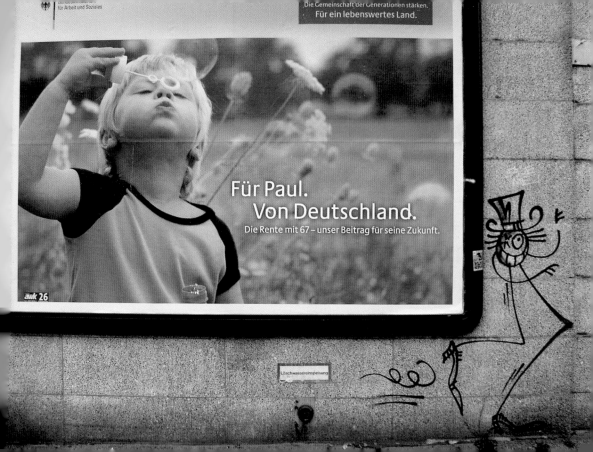

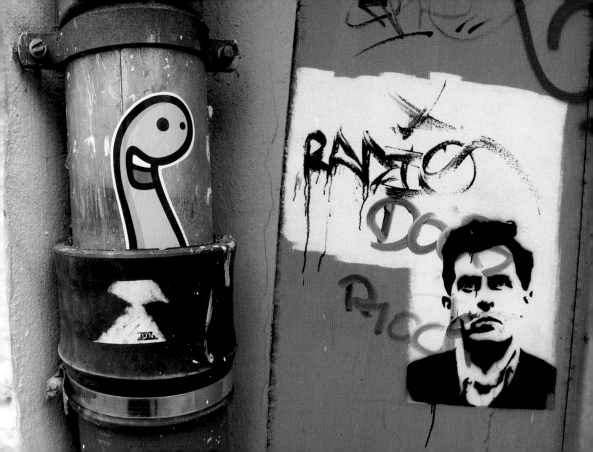

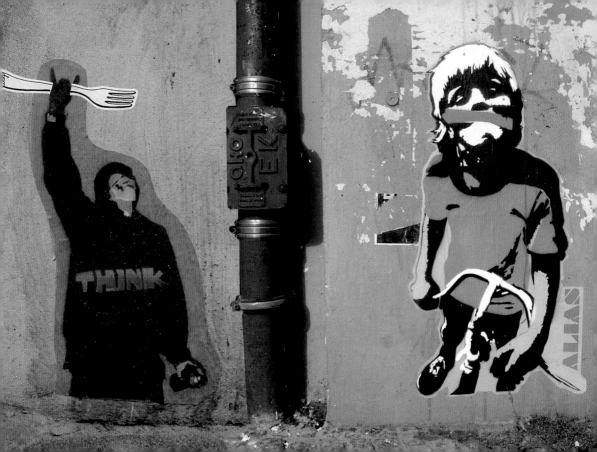

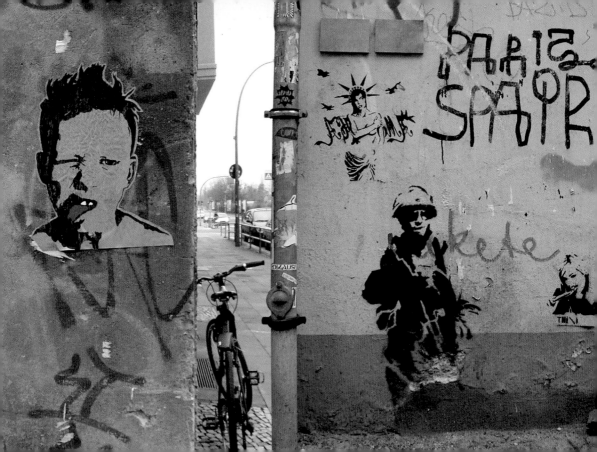

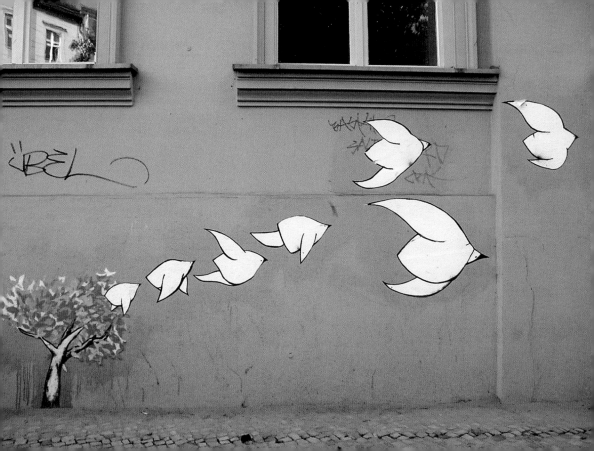

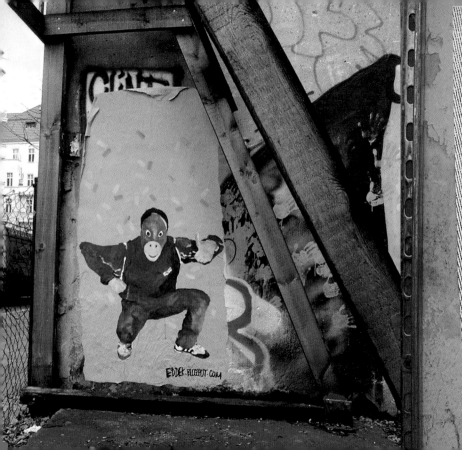

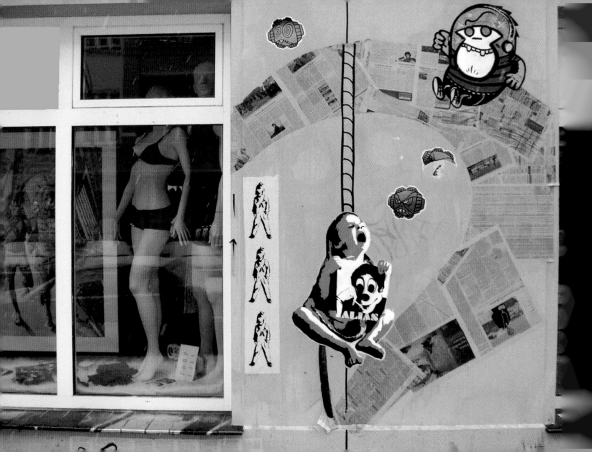

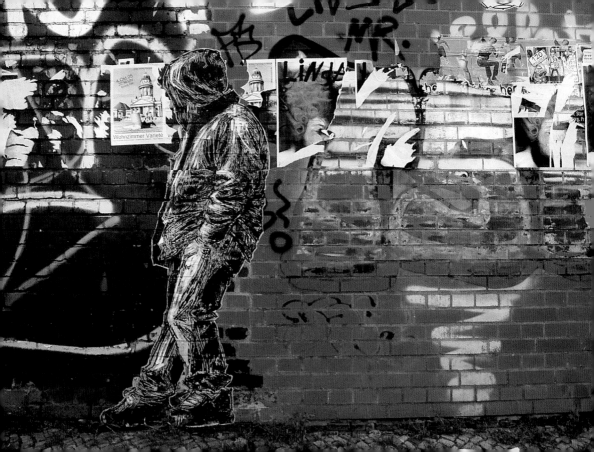

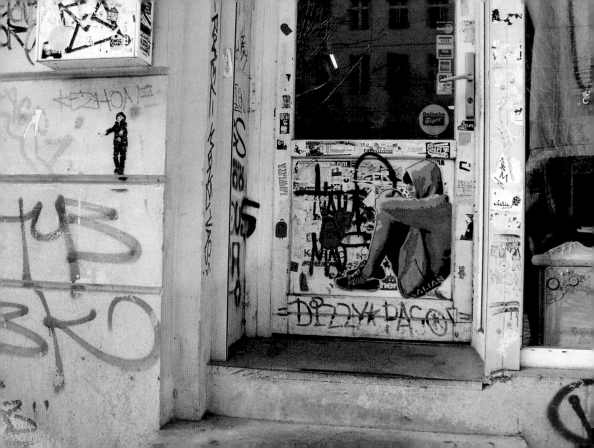

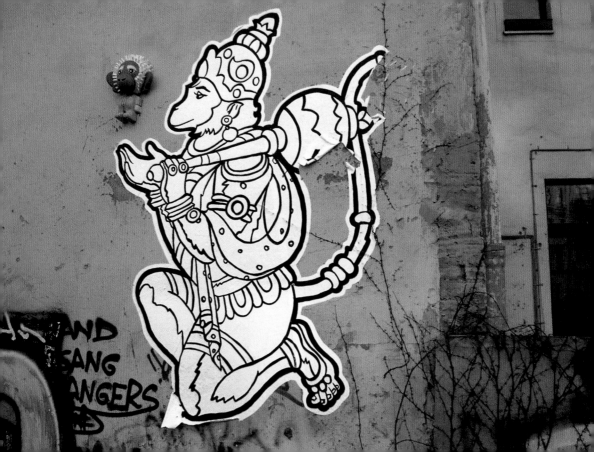

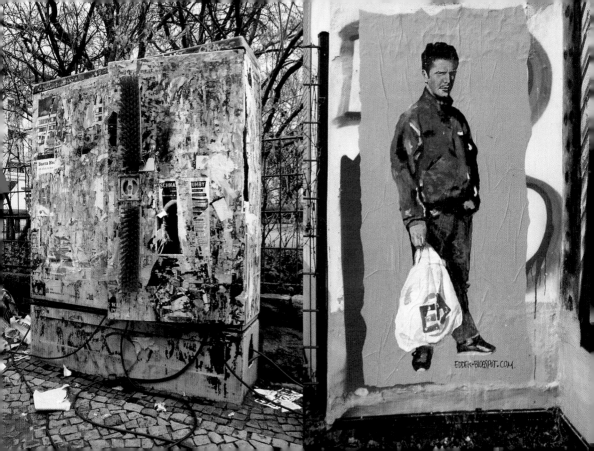

EDDEK-BLOGSPOT.COM

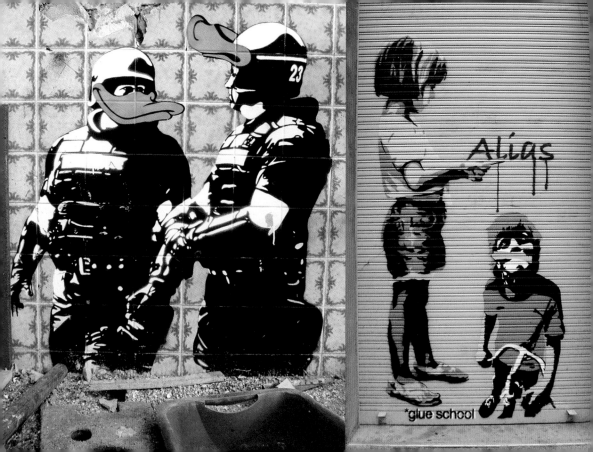

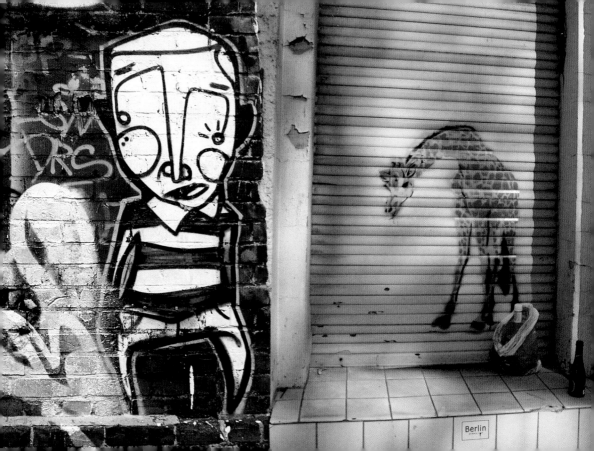

Berlin

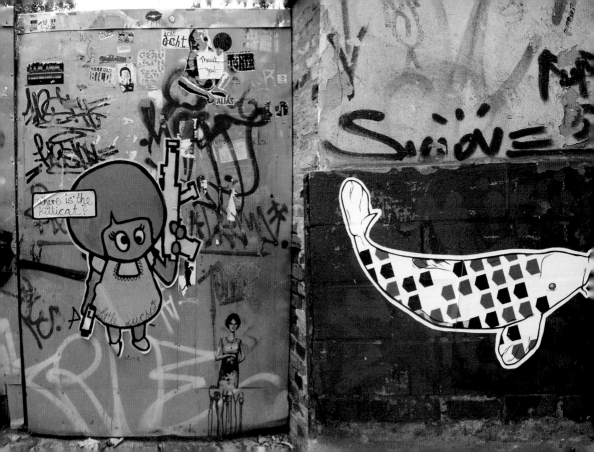

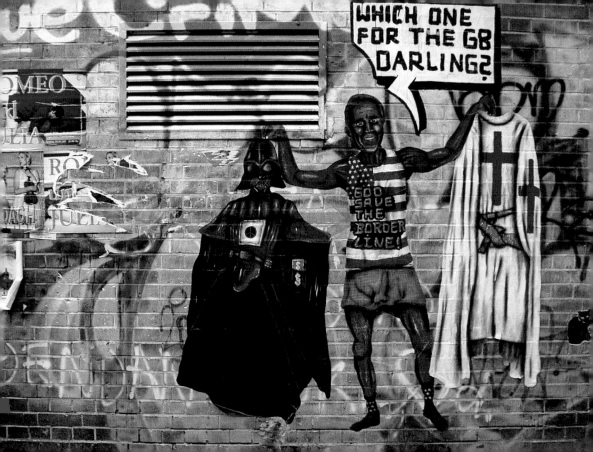

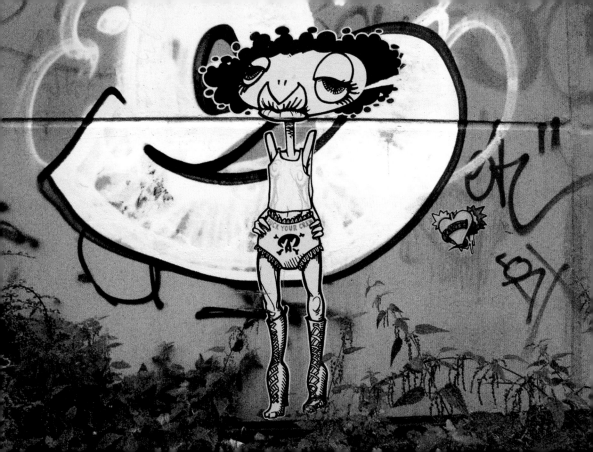

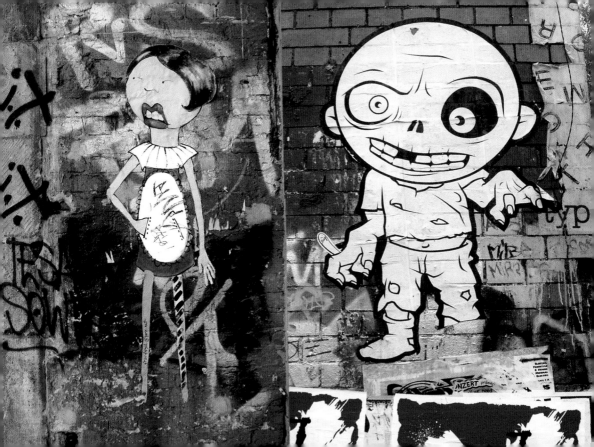

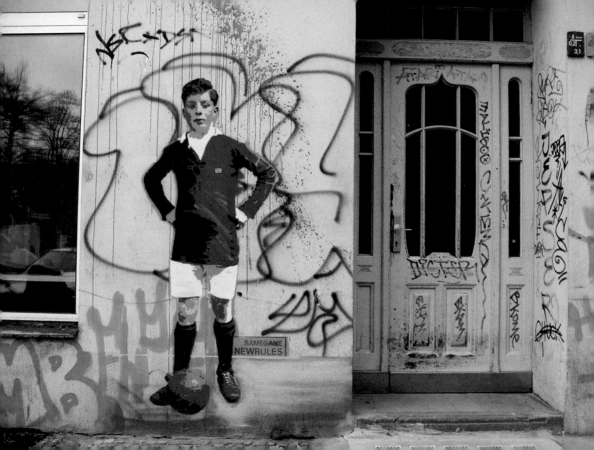

SAMEGAME
NEWRULES

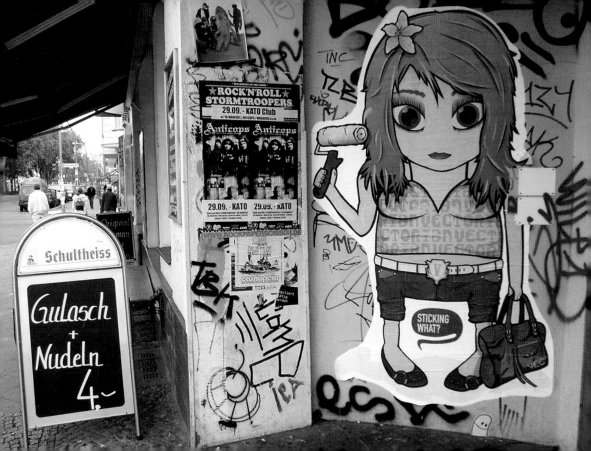

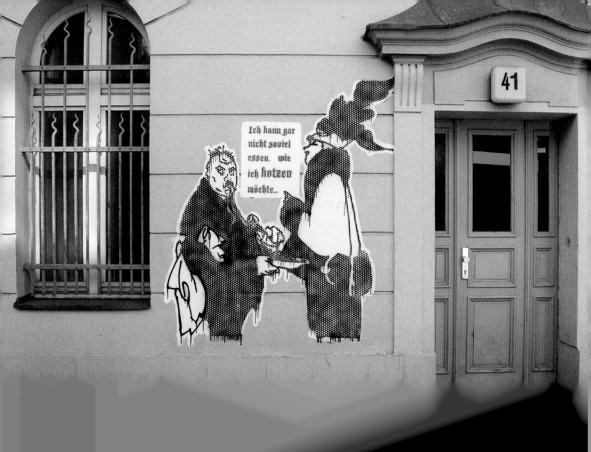

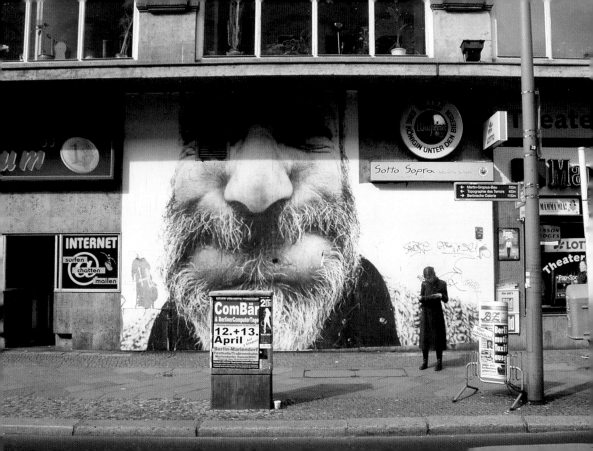

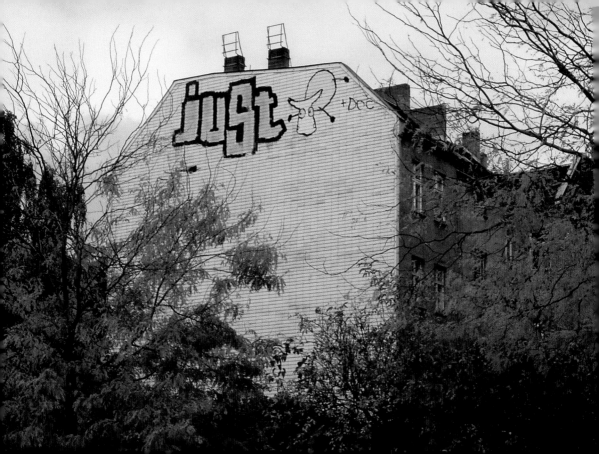

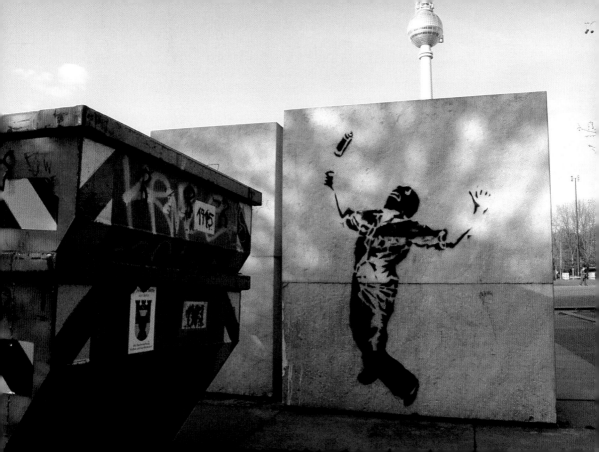

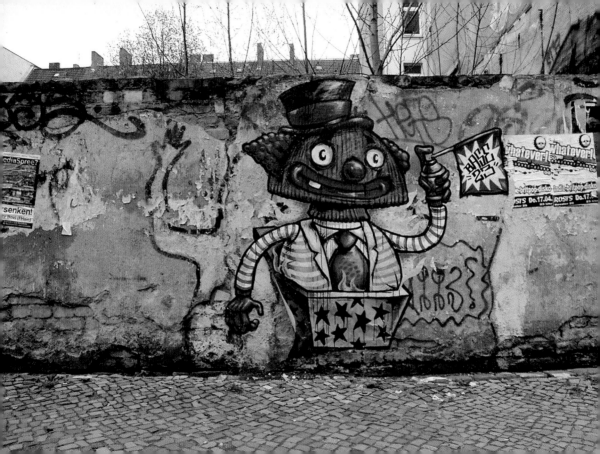

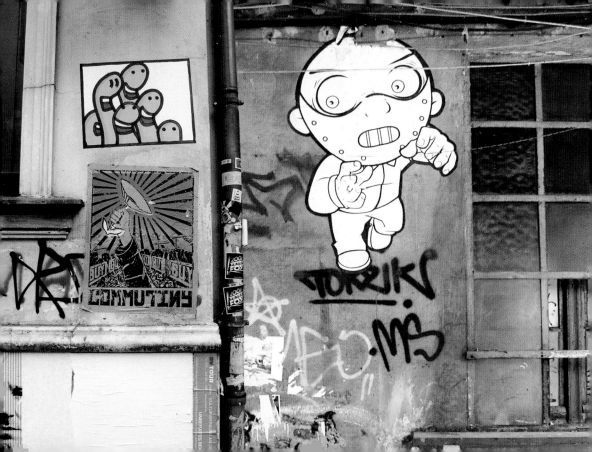

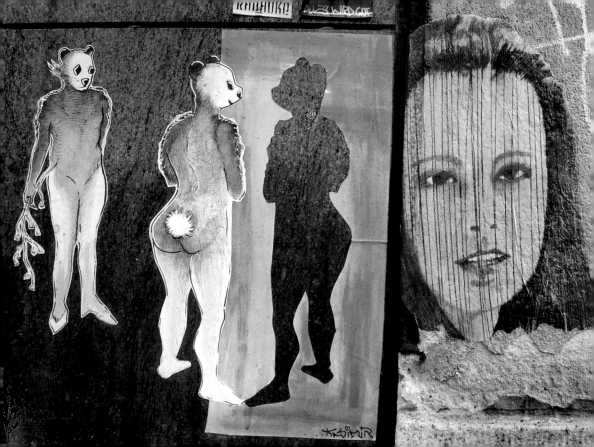

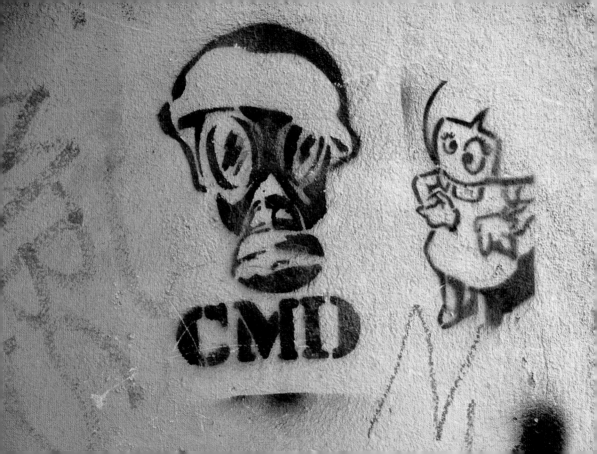

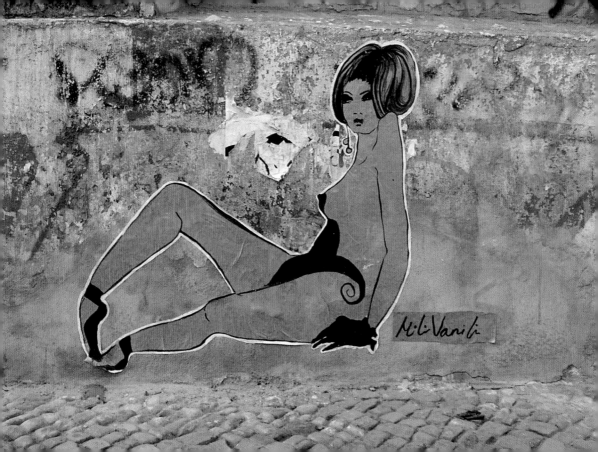

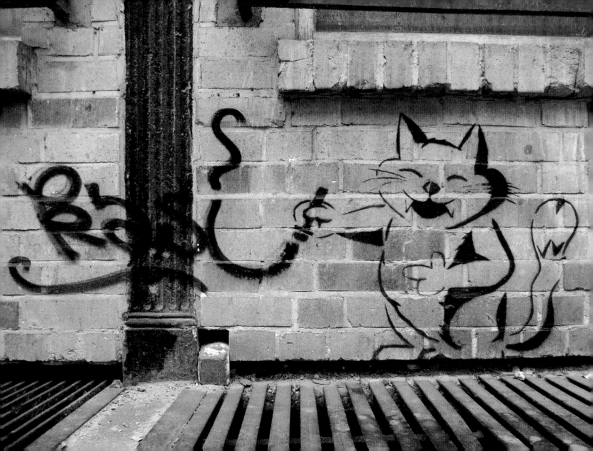

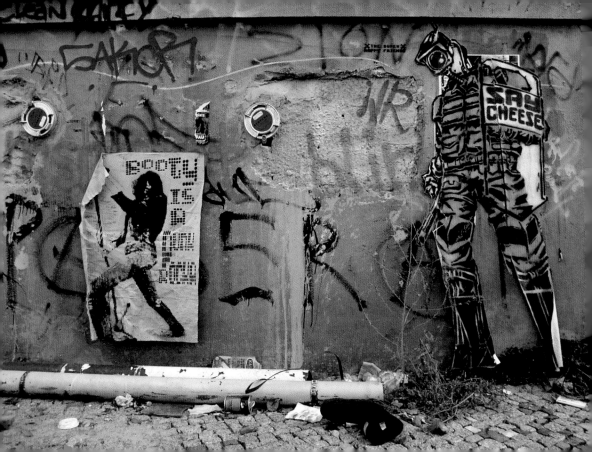

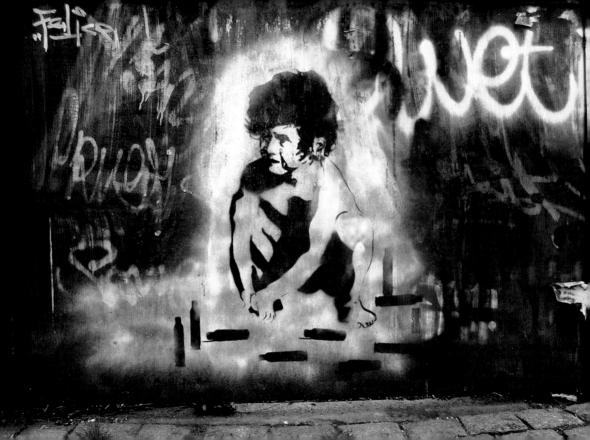

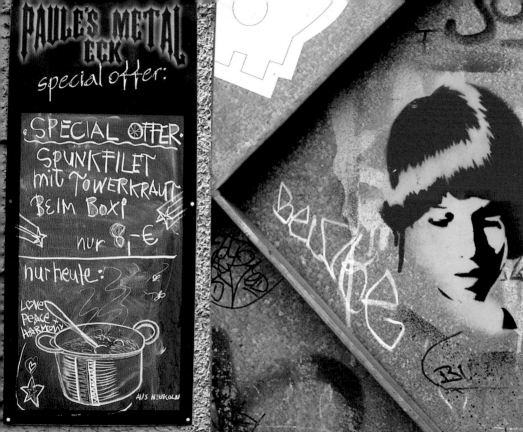

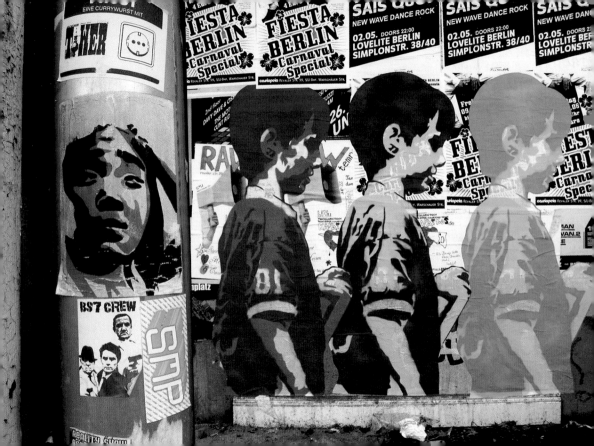

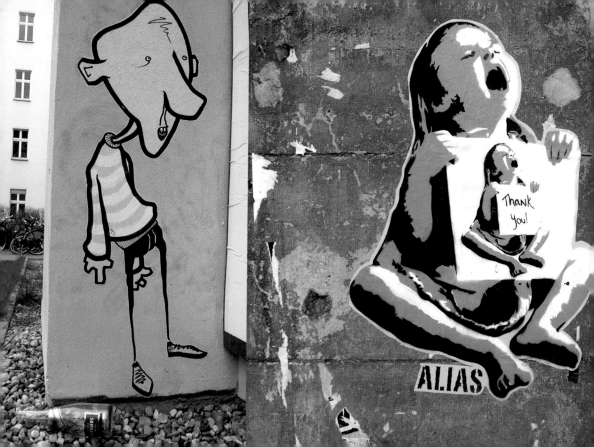

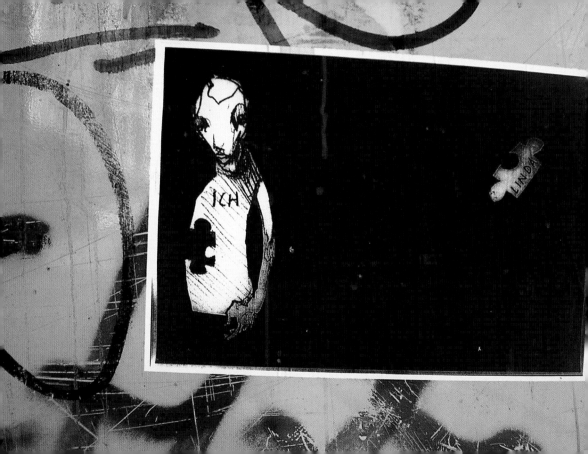

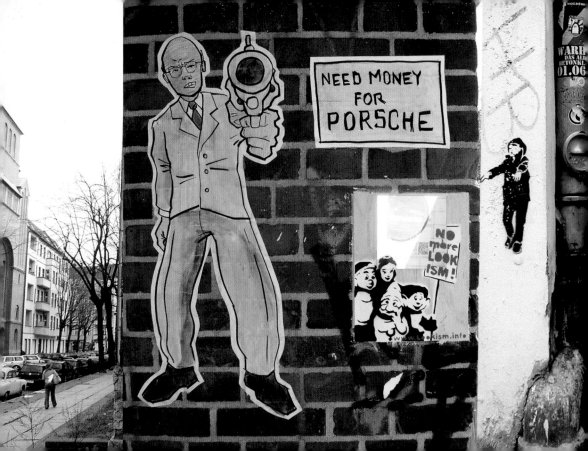

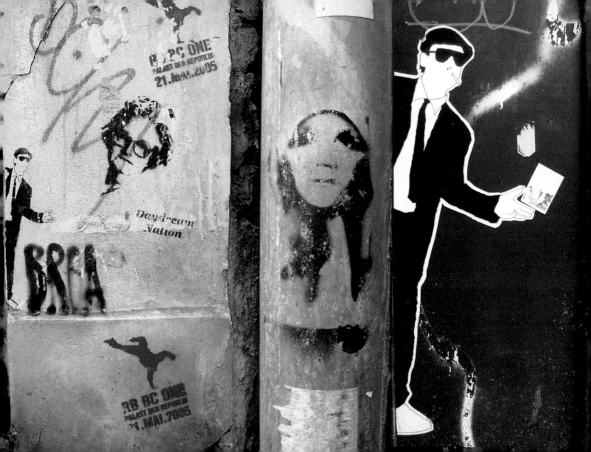

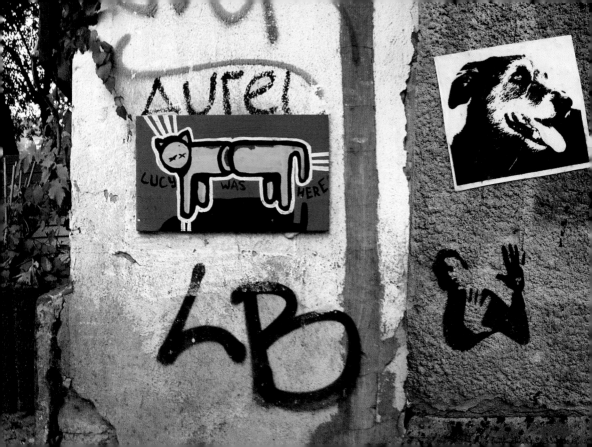

LUCY WAS HERE

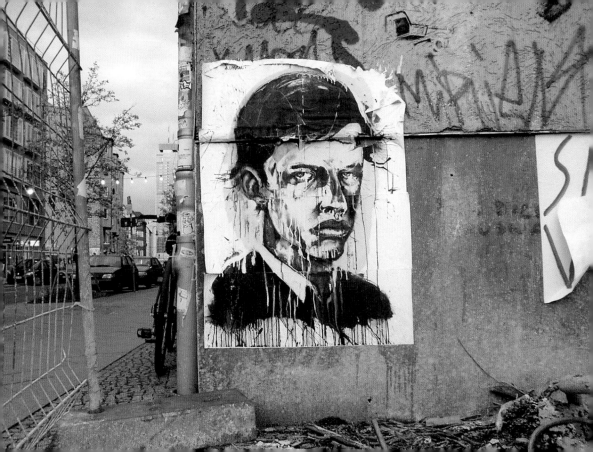

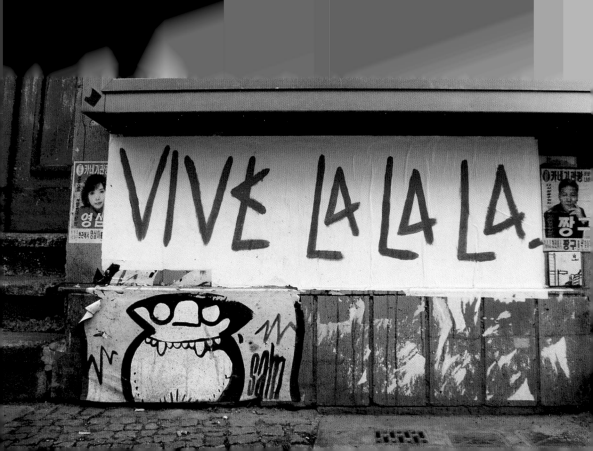

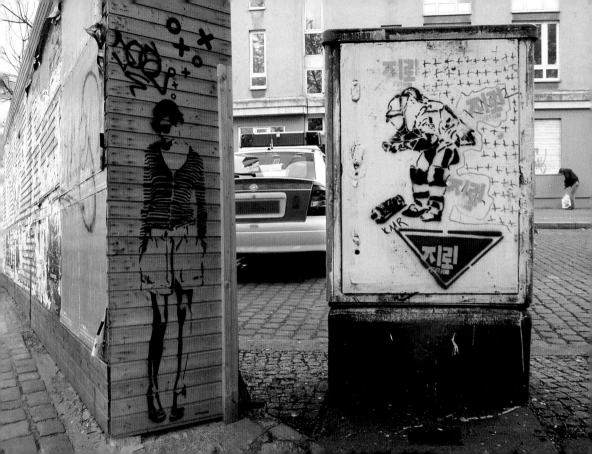

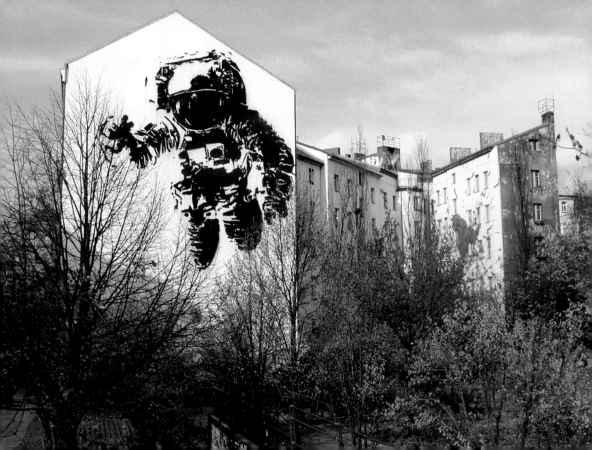

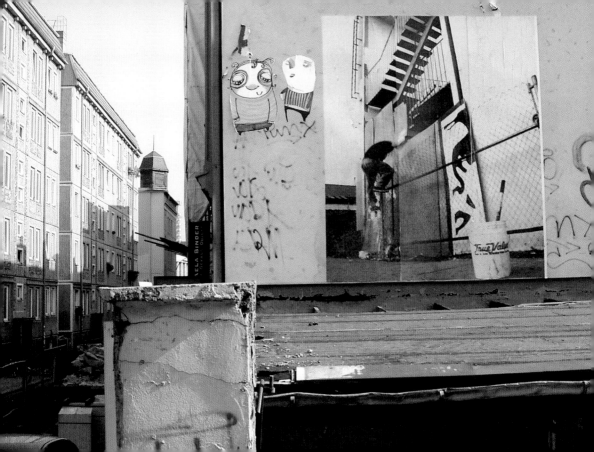

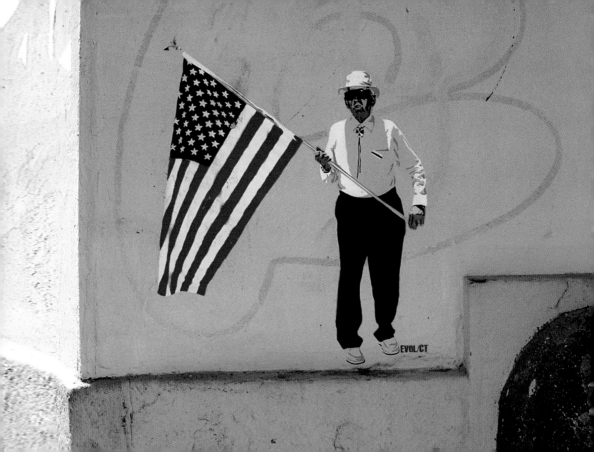

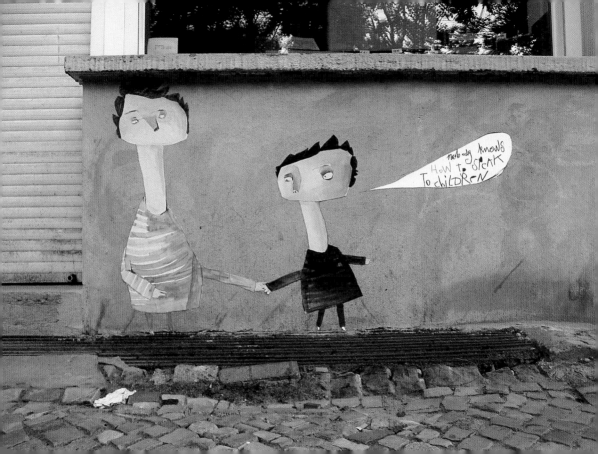

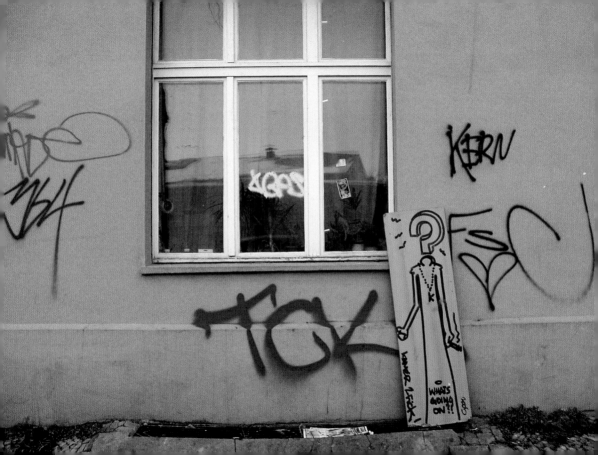

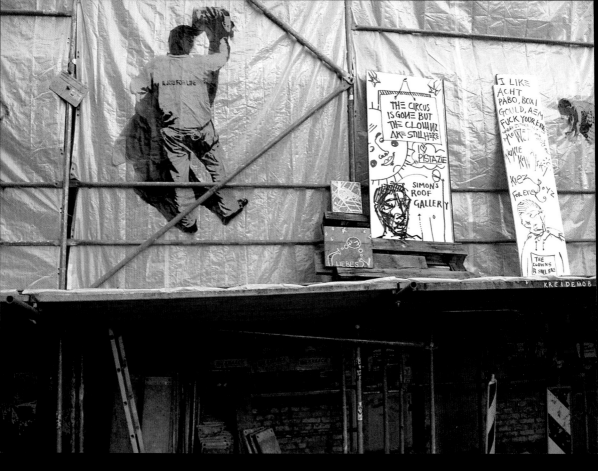

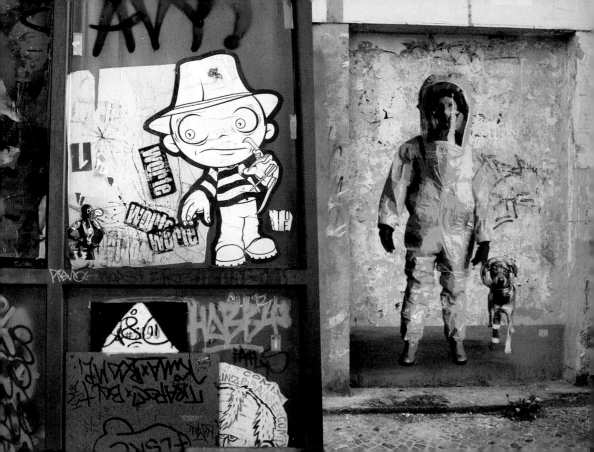

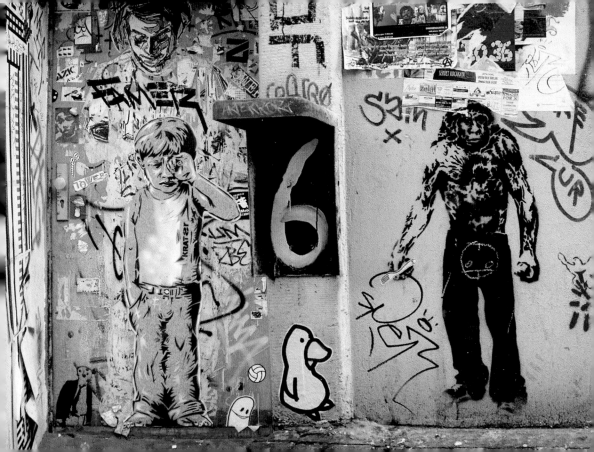

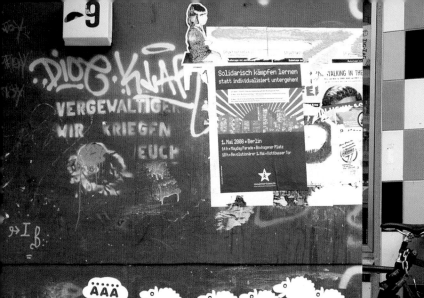

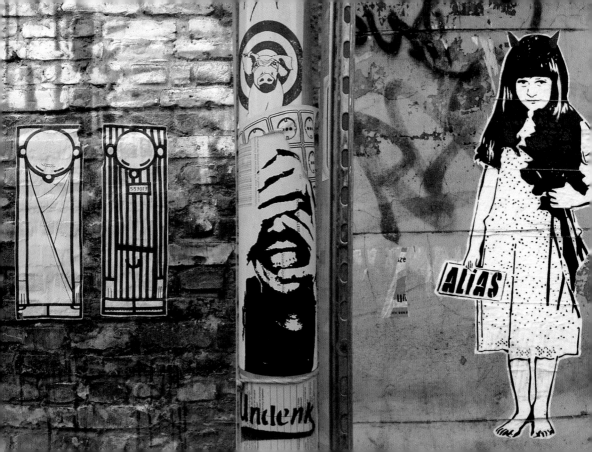

S37017

Undenk

ALIAS

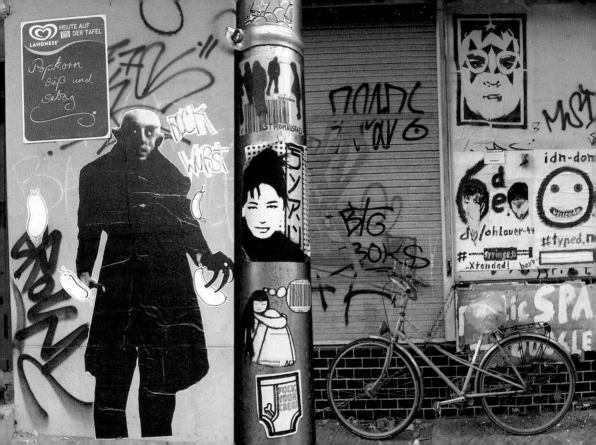

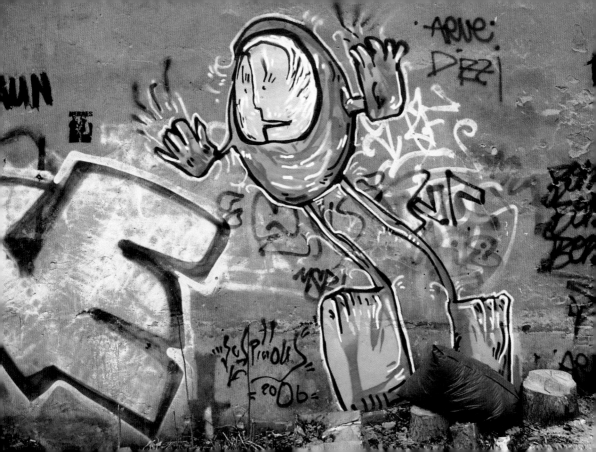

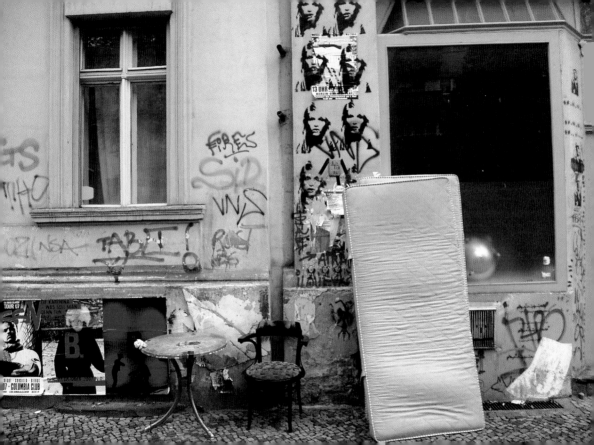

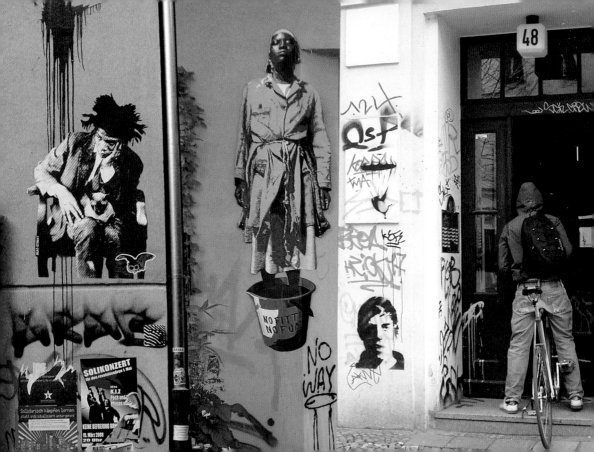

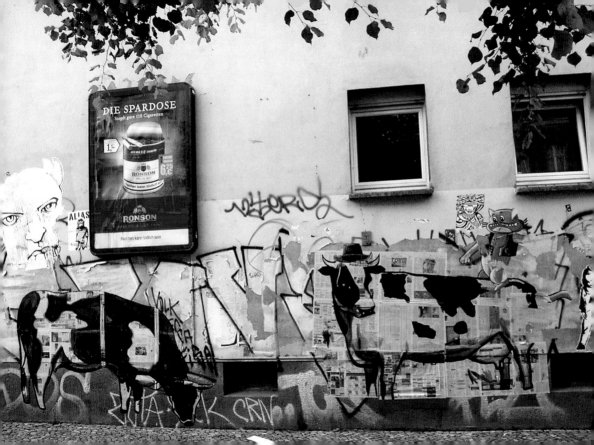

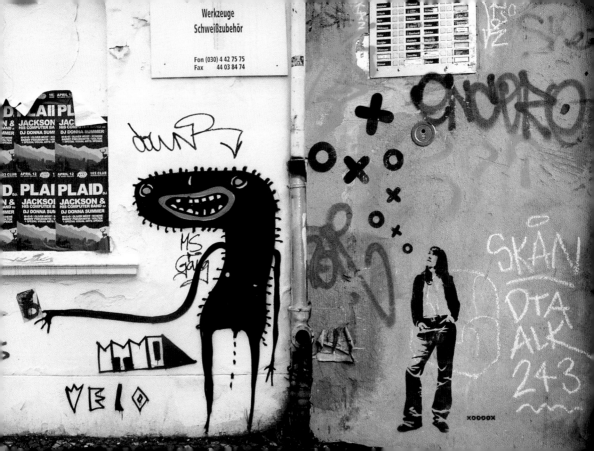

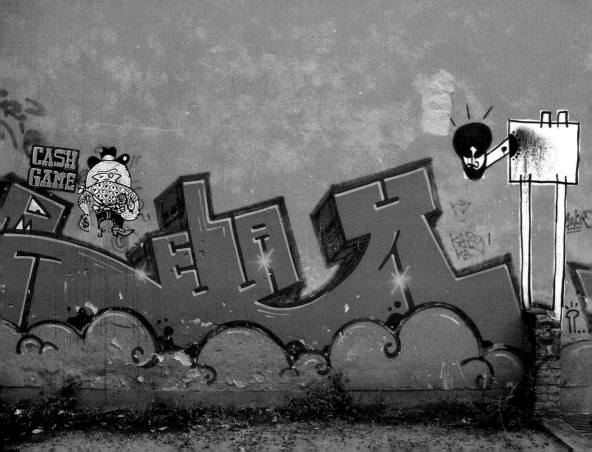

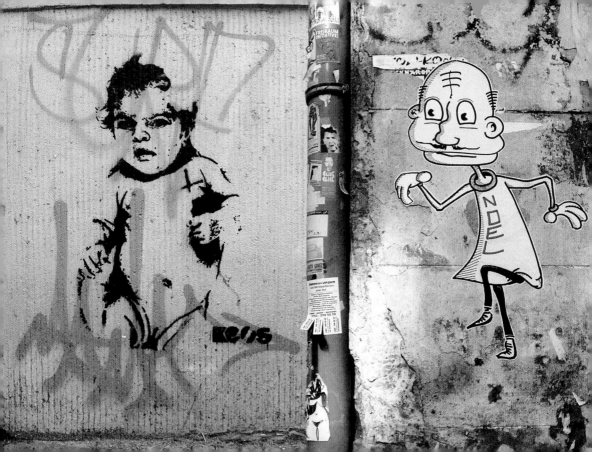

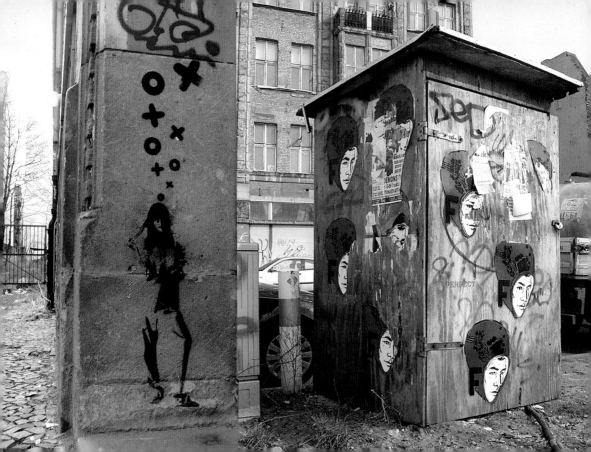

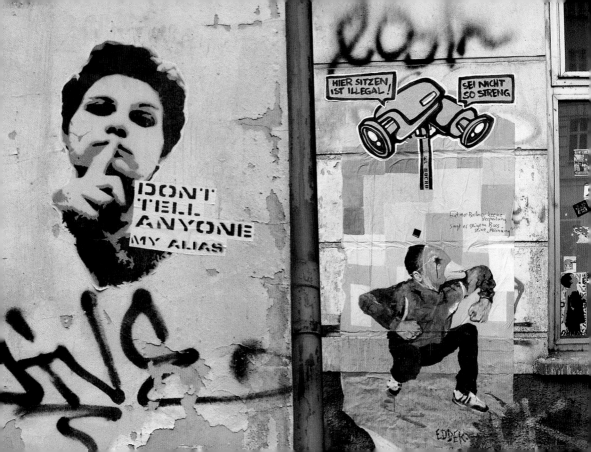

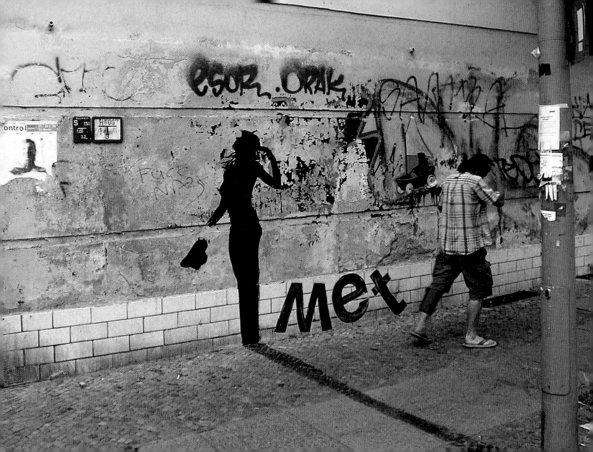

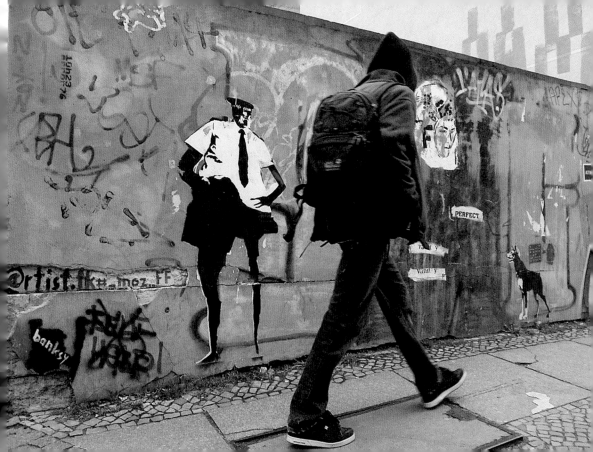

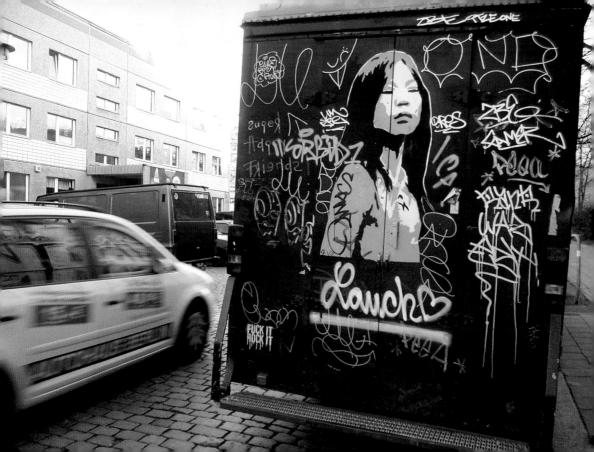

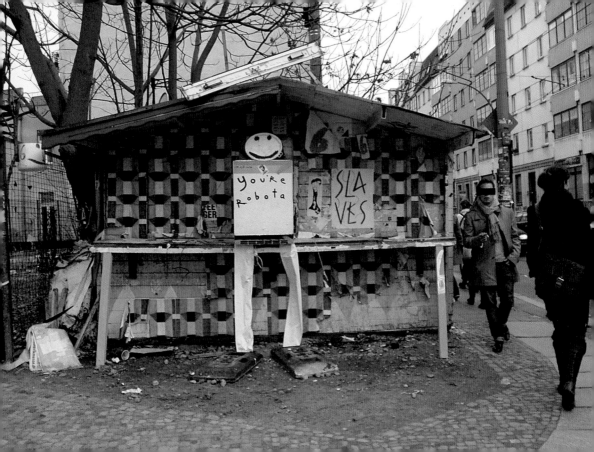

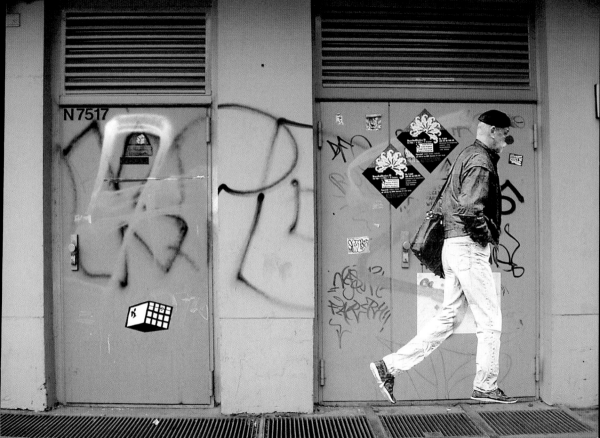

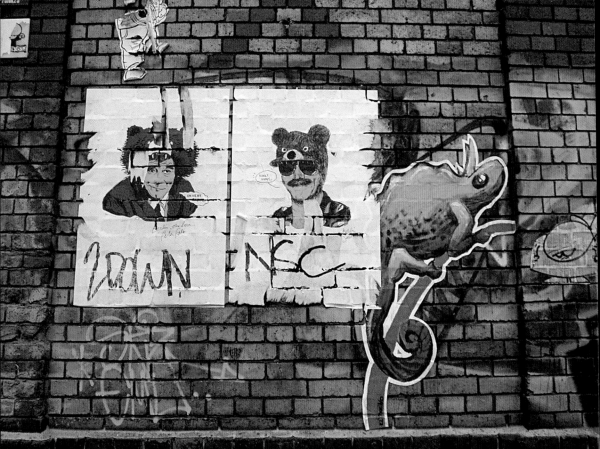

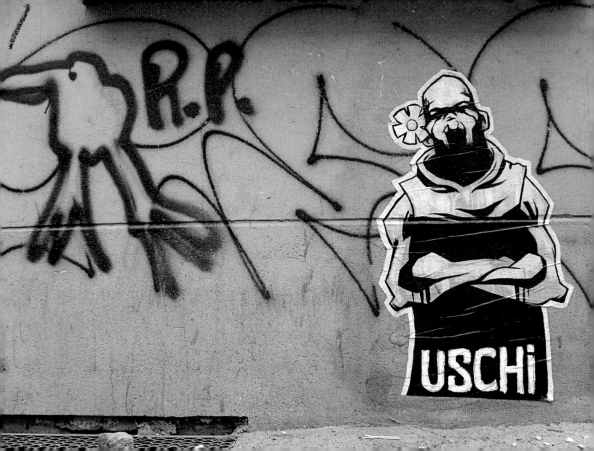

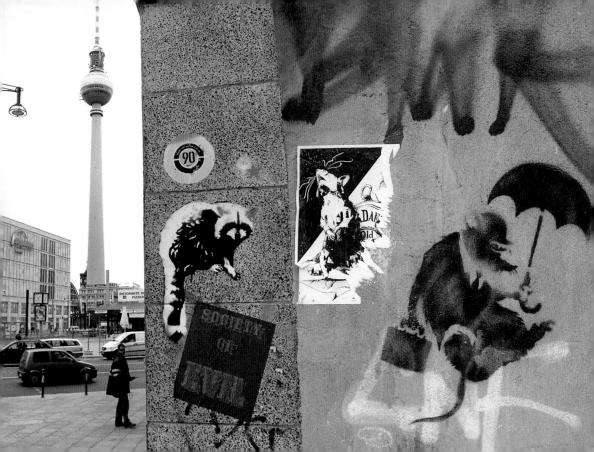

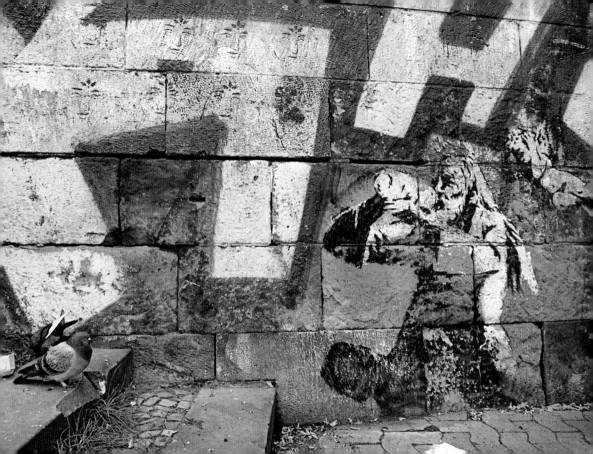

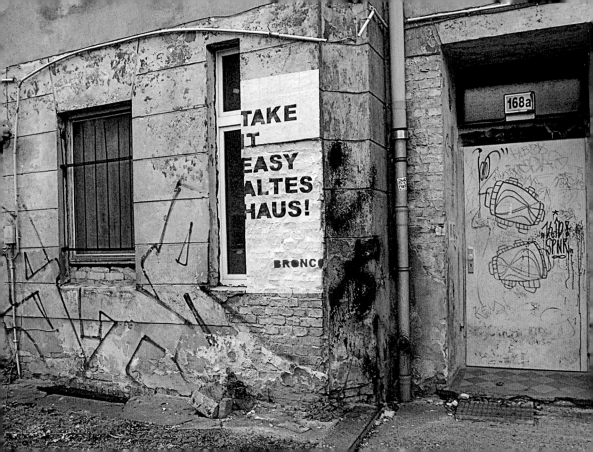

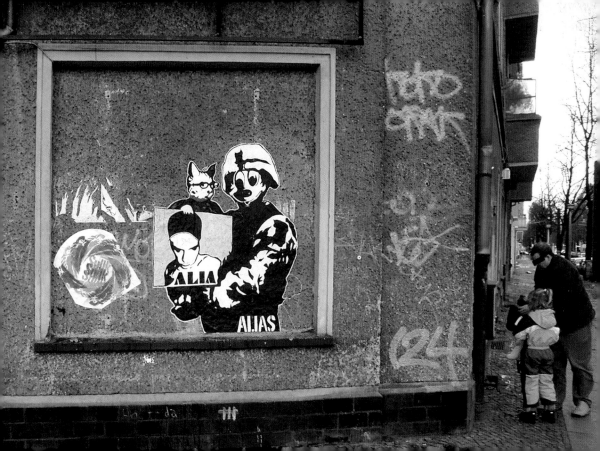

© Prestel Verlag

Munich · Berlin · London · New York, 2008

Die Deutsche Bibliothek verzeichnet diese Publikation in
der Deutschen Nationalbibliografie; detaillierte bibliografische
Angaben sind im Internet über http://dnb.ddb.de abrufbar

Die Deutsche Bibliothek lists this publication in the Deutsche
Nationalbibliografie; detailed bibliographic data is available
on the Internet at http://dnb.ddb.de

Library of Congress Control Number: 2008929209

Prestel Verlag
Königinstraße 9, D-80539 München
Tel. +49 (89) 24 29 08-300, Fax +49 (89) 24 29 08-335
info@prestel.de

Prestel Verlag
Büro Berlin
Husemannstraße 26, D-10435 Berlin
Tel. +49 (30) 425 01 85, Fax +49 (30) 425 01 85
www.prestel.de

Prestel Publishing Ltd.
4 Bloomsbury Place, London WC1A 2QA
Tel. +44 (0)20 7323-5004, Fax +44 (0)20 7636-8004

Prestel Publishing
900 Broadway, Suite 603, New York, N.Y. 10003
Tel. +1 (212) 995-2720, Fax +1 (212) 995-2733
www.prestel.com

Prestel books are available worldwide.

Please contact your nearest bookseller or write to
one of the addresses listed on the left for information
concerning your local distributor.

Übersetzung / Translation: Jennifer Beckers

Lektorat / Editor: Frauke Berchtig

Gestaltung / Design: Sven Zimmermann, Berlin

Herstellung / Layout:
typo//designbüro, uta thieme & jens wolfram, Berlin

Reproduktion / Origination: Reproline Genceller, München

Druck und Bindung / Printing and binding:
TBB, Banská Bystrica

Fotonachweis / Photographic credits:
Alle Aufnahmen stammen von / All photographs by
© Sven Zimmermann, Berlin

Gedruckt in der Slowakischen Republik
auf chlorfrei gebleichtem Papier /
Printed in Slovakia on acid-free paper

ISBN 978-3-7913-4069-2

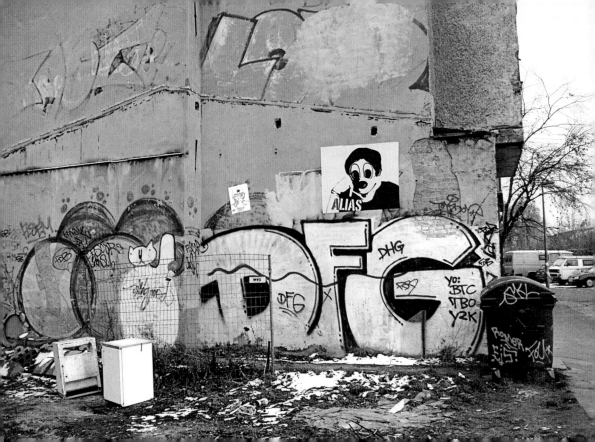

Berlin Street Art Websites

reclaimyourcity.net

just.blogsport.de

buart.de

rebelart.net

4rtist.com

ostblog.berlinpiraten.de

german-street-art.blogspot.com

streetarts.blogspot.com

stencilart-berlin.de.vu

for further links please see:
reclaimyourcity.net/links/links.php

LINKS

MySpace Artist Sites

myspace.com/noooel

myspace.com/woistlinda

myspace.com/aliaslovesyou

myspace.com/grafikklub7

myspace.com/xooooxoooox

myspace.com/funk_25

myspace.com/karl_toon

myspace.com/thinksflowjob

myspace.com/web_2_0#%3C::::::::::||==o

myspace.com/pixel_monster

myspace.com/mymonstersworld

myspace.com/vectorian

myspace.com/nomad_yesmad

myspace.com/mikoshbonk

el bocho: myspace.com/289792320